Paul Trimble Has A Posse

Devin Sheehy

Porkopolis Productions

Cincinnati, Ohio

Devin Sheehy

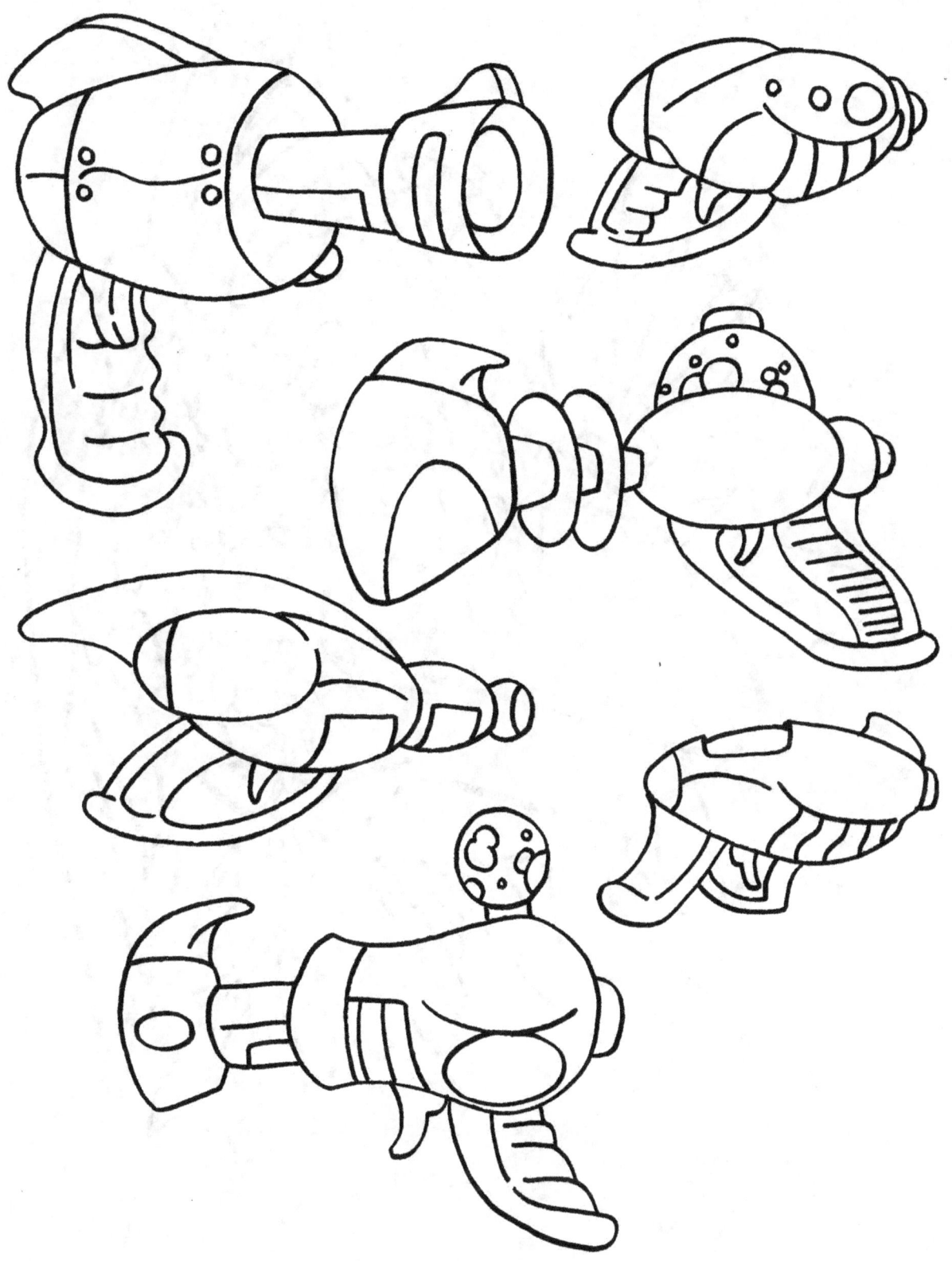

Paul Trimble Has A Posse

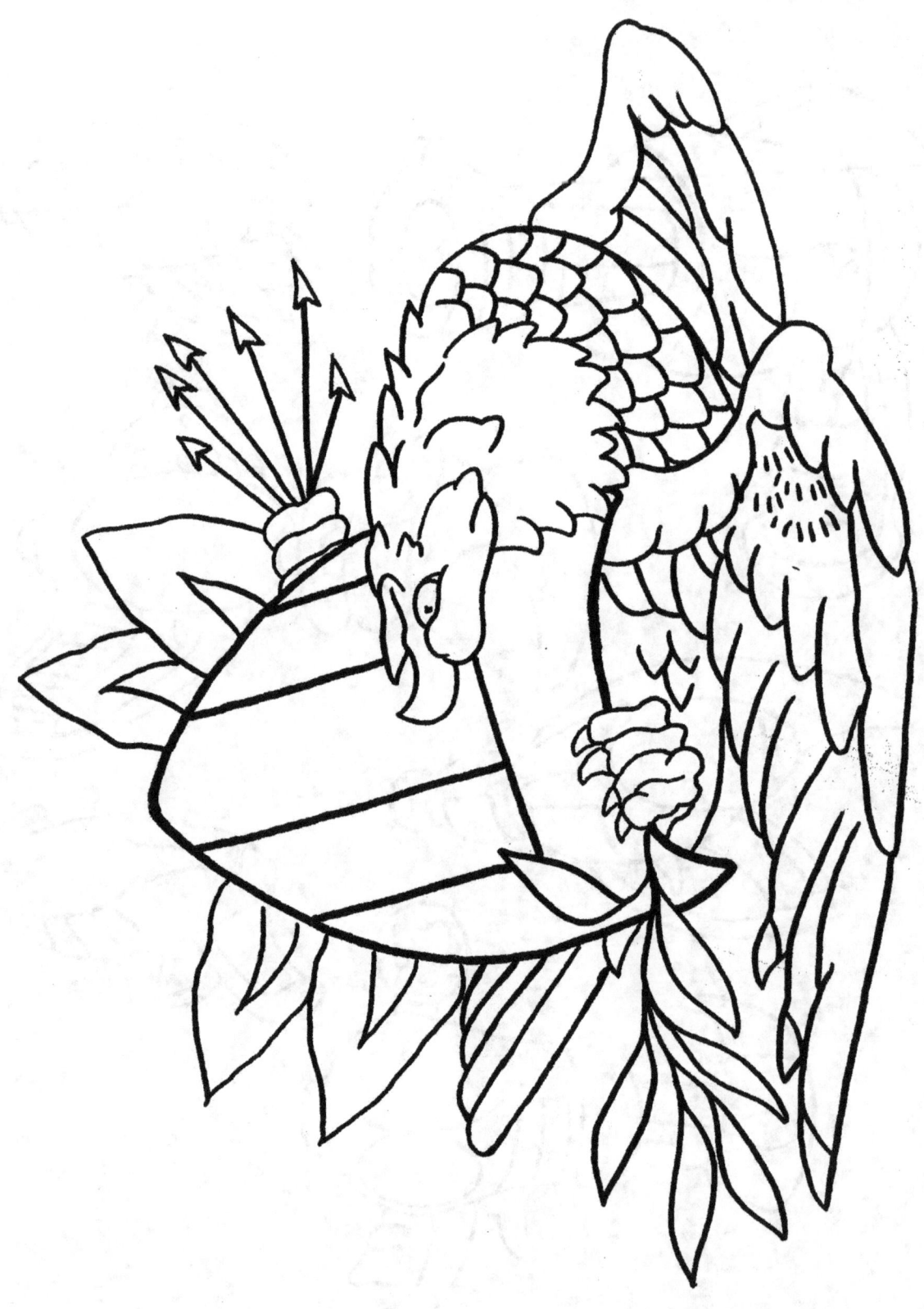

Devin Sheehy

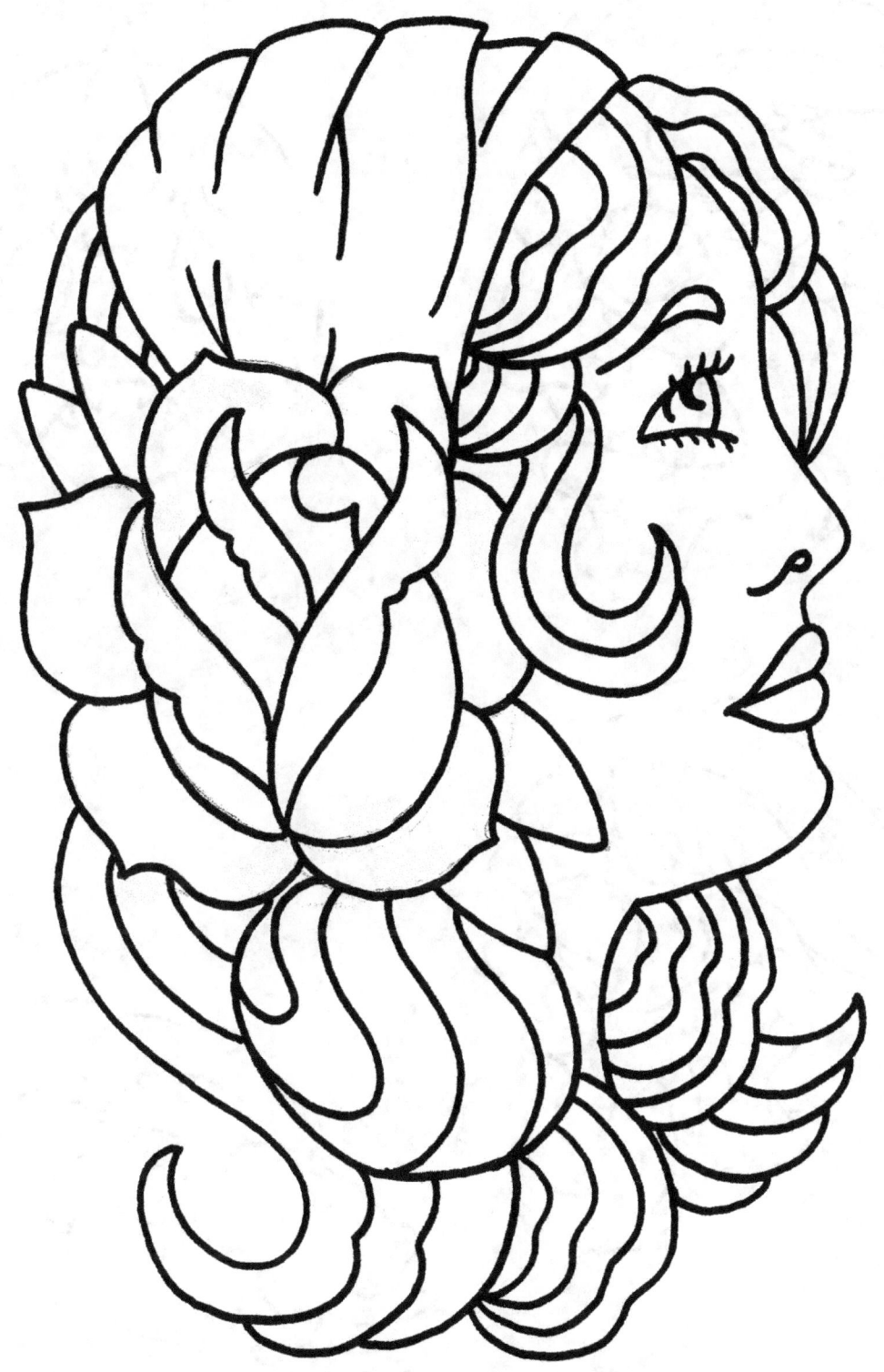

Paul Trimble Has A Posse

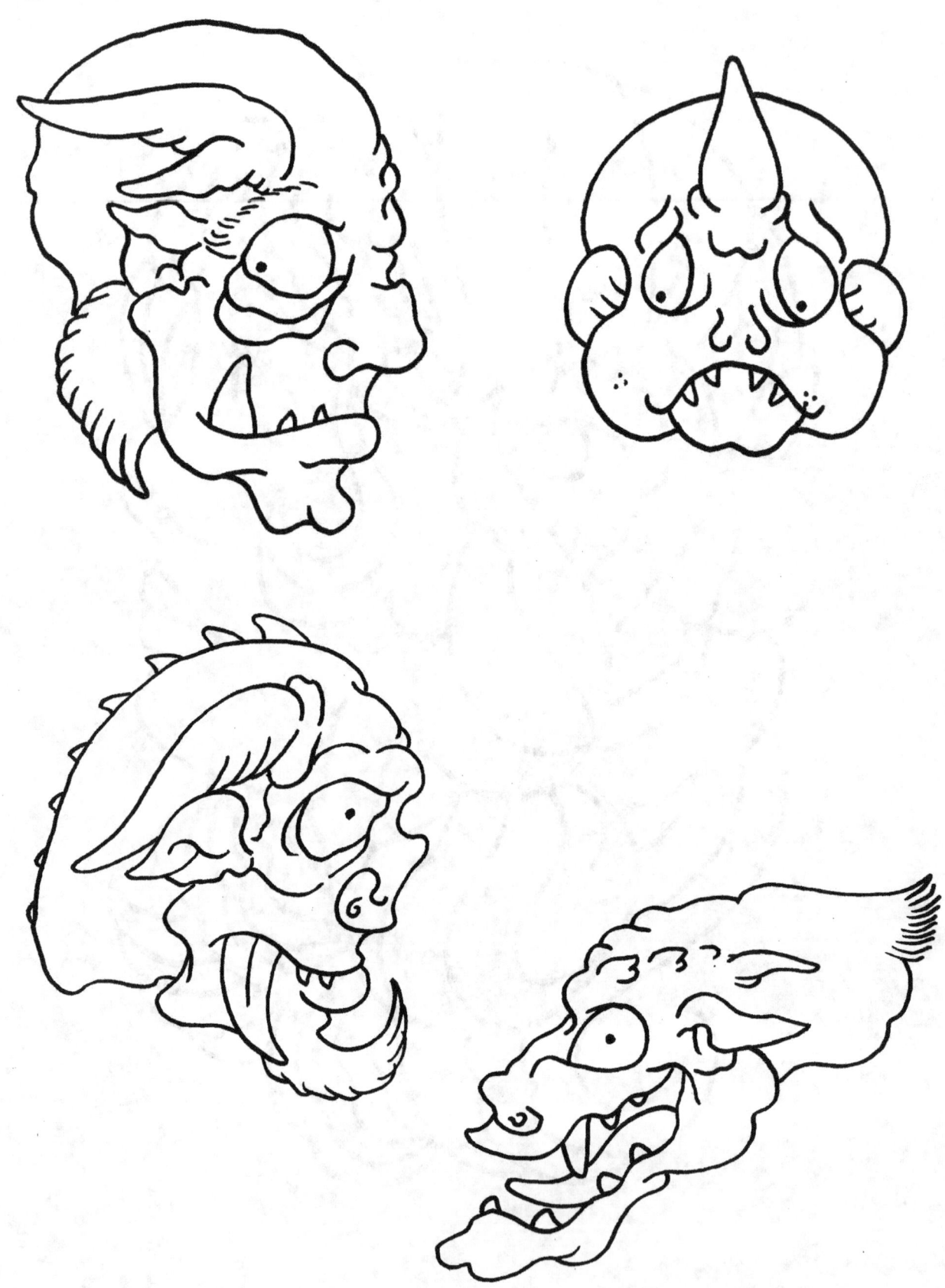

Devin Sheehy

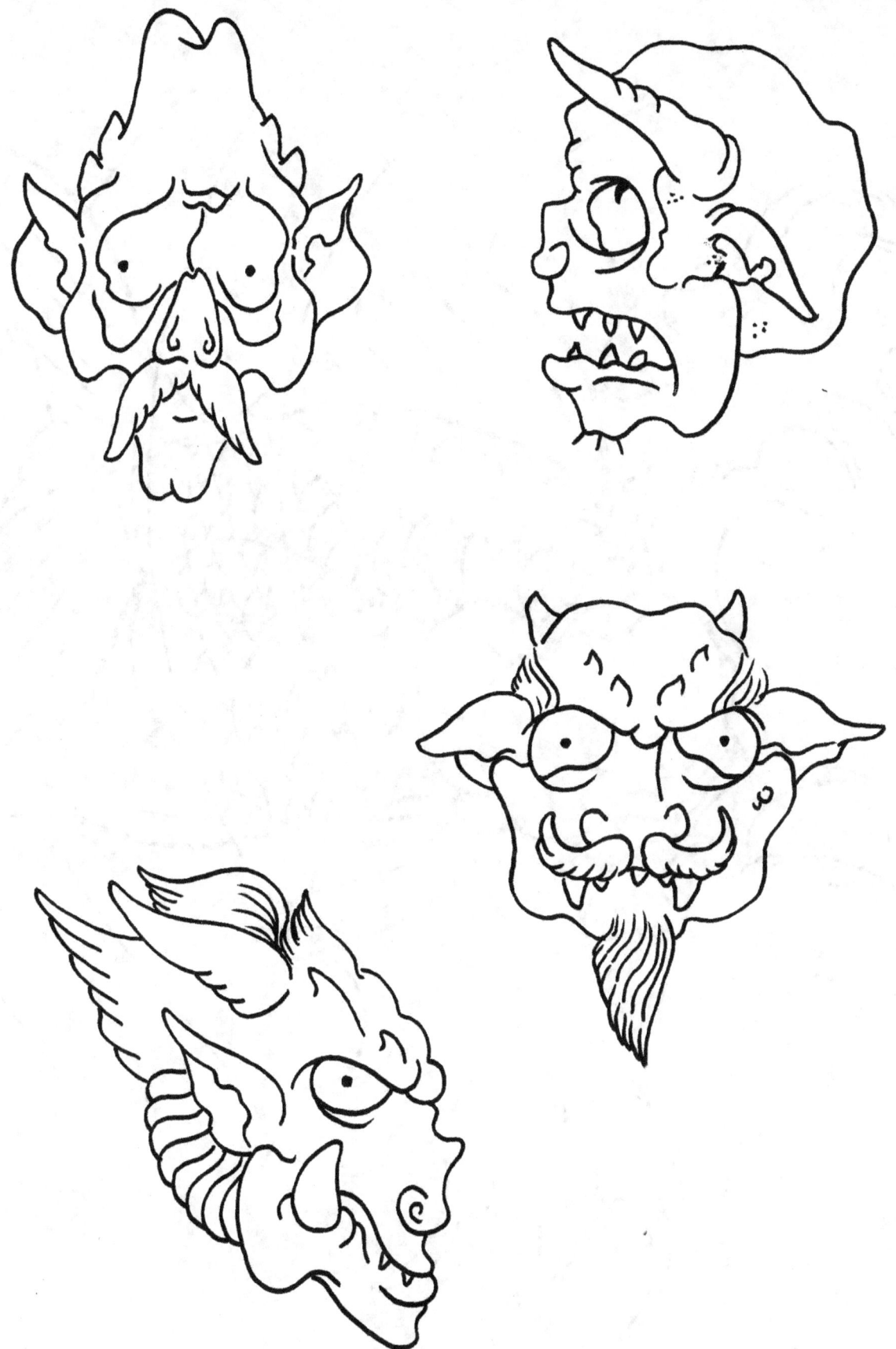

Paul Trimble Has A Posse

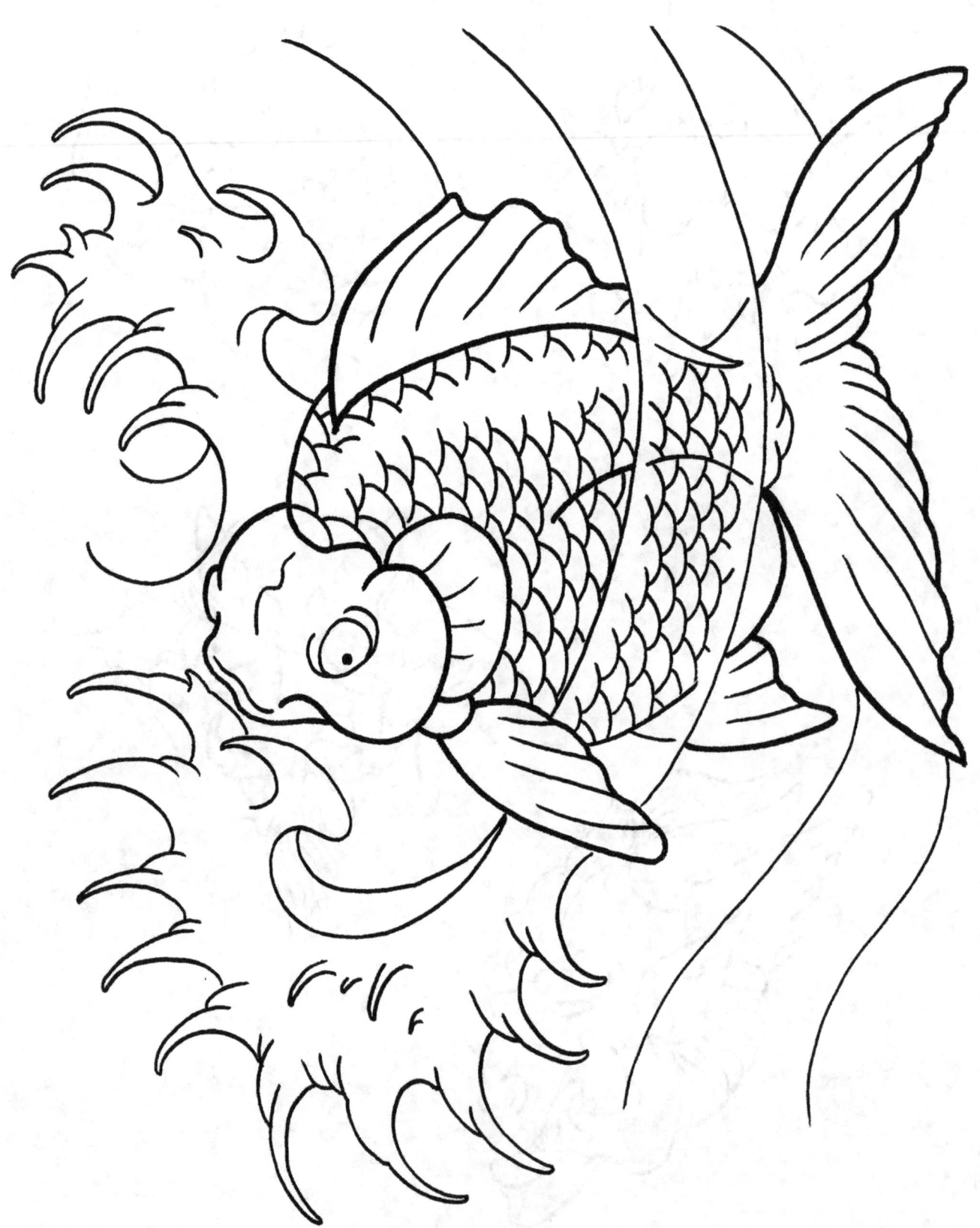

Devin Sheehy

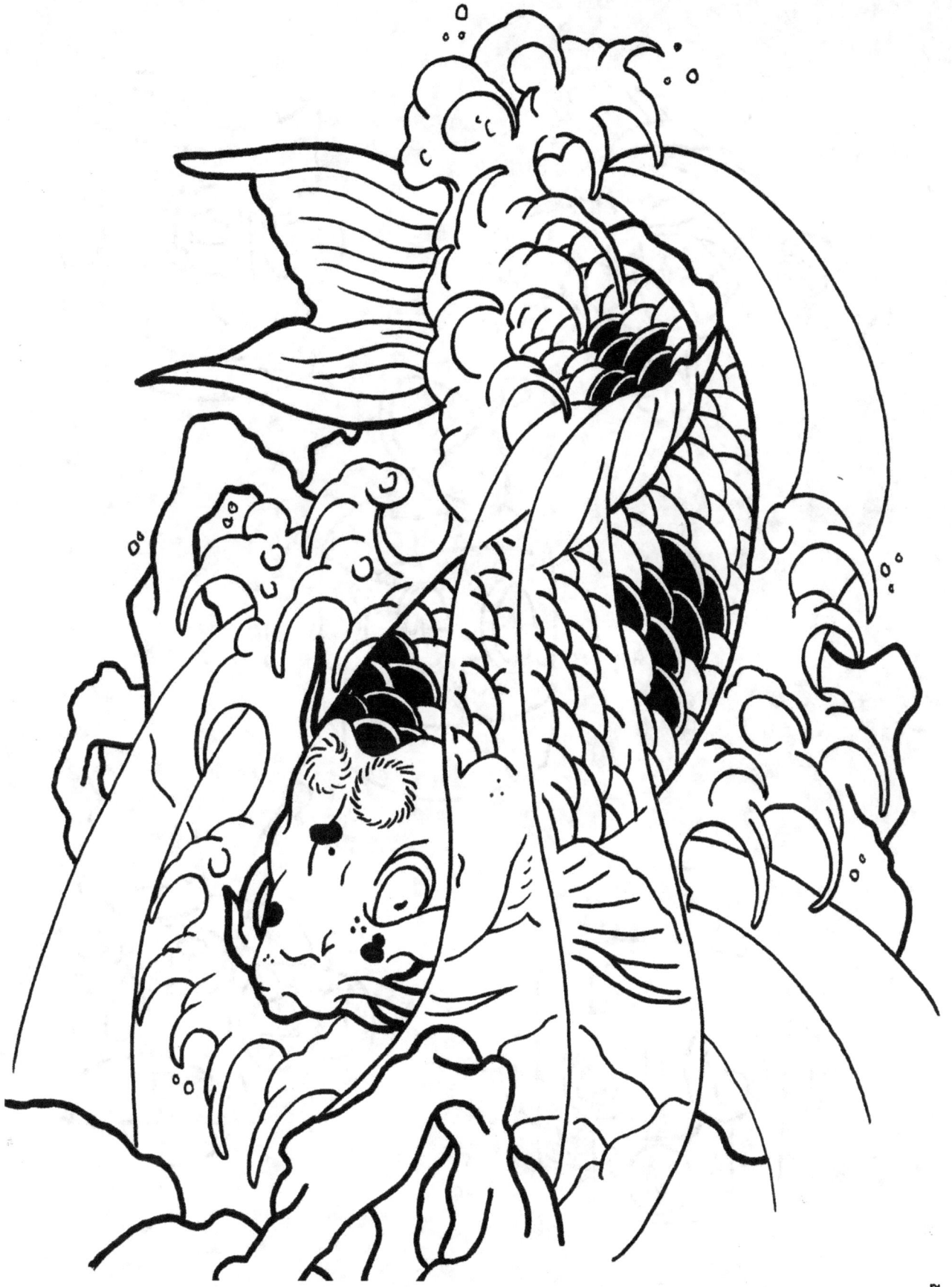

Paul Trimble Has A Posse

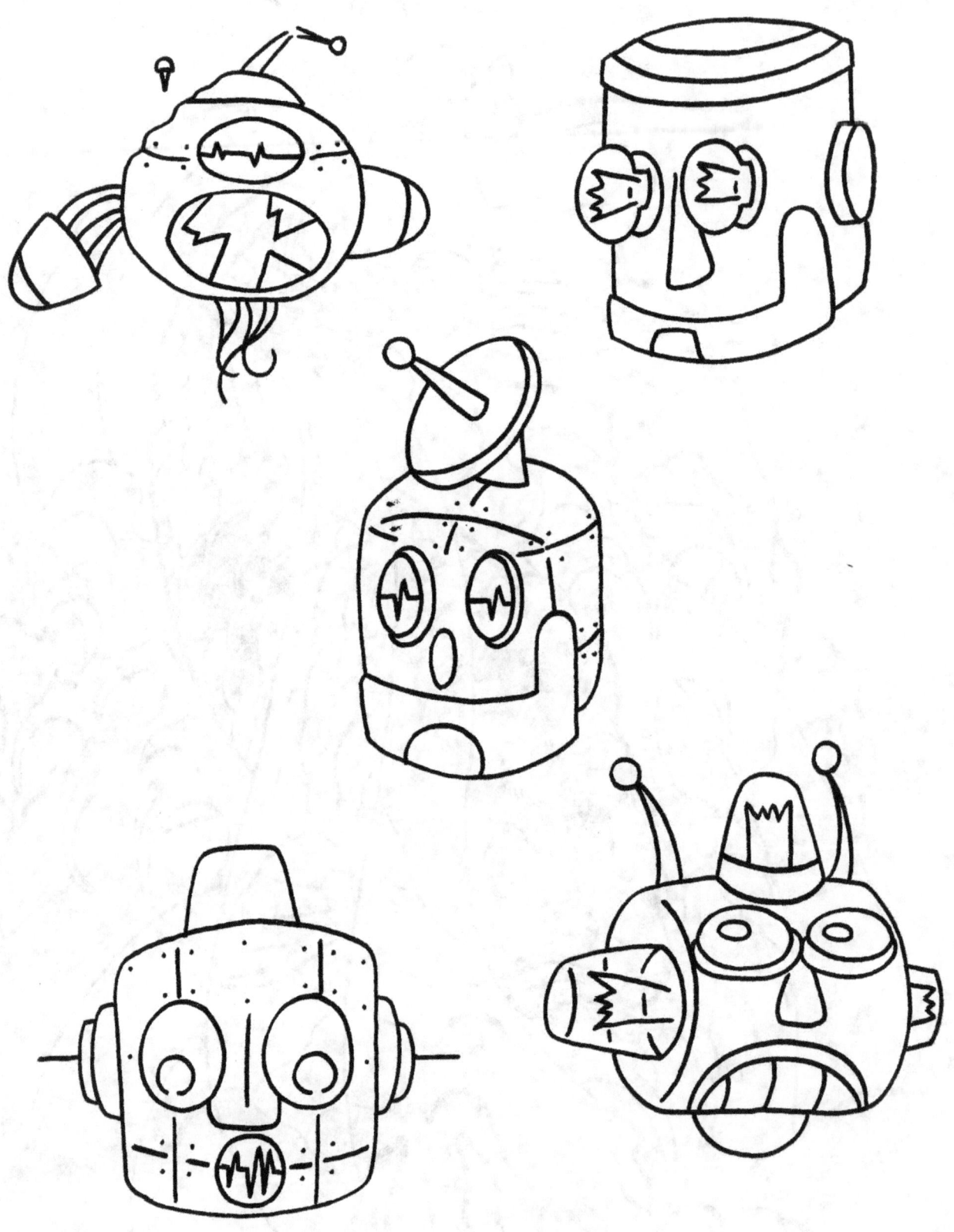

Devin Sheehy

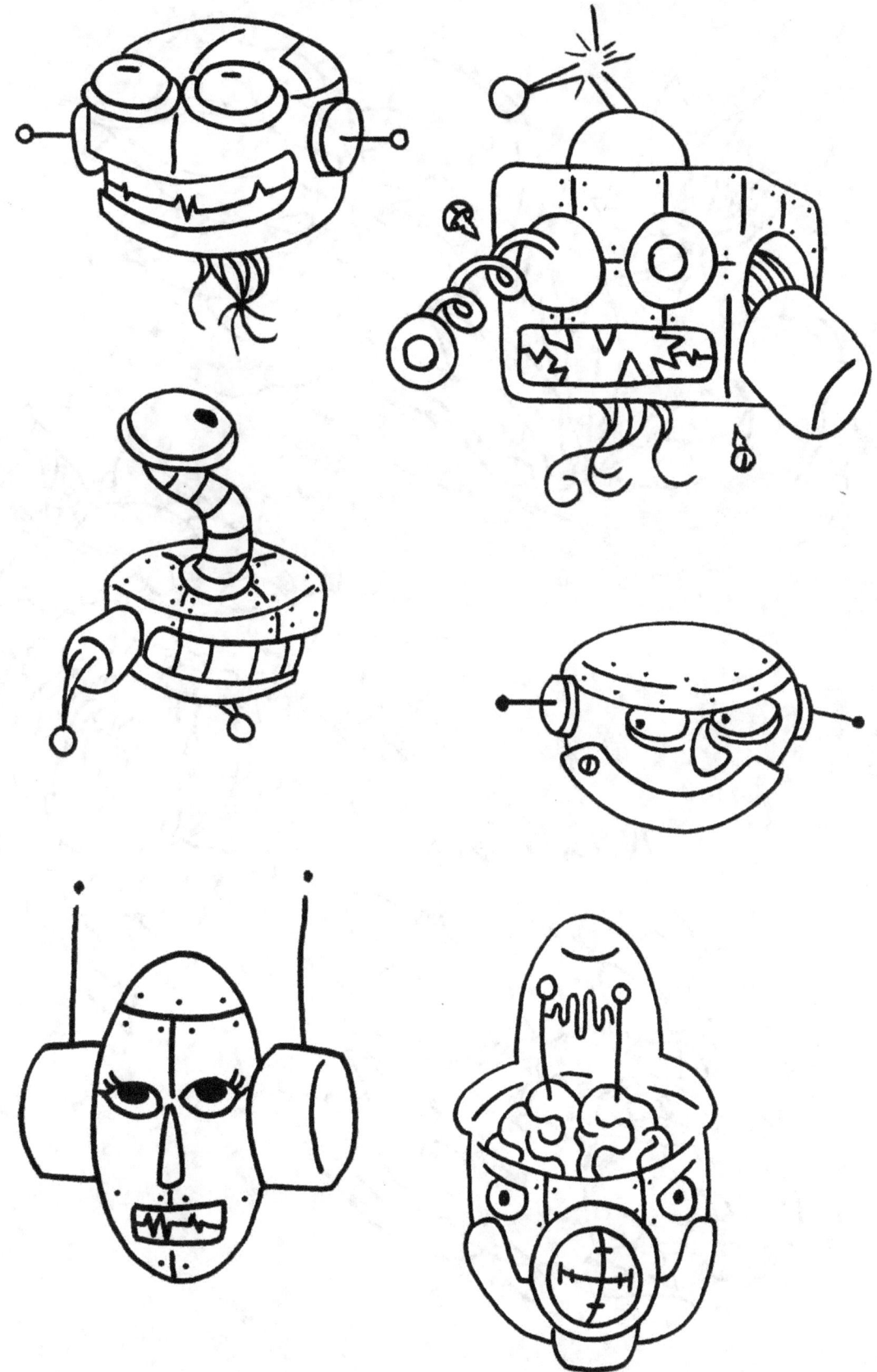

Paul Trimble Has A Posse

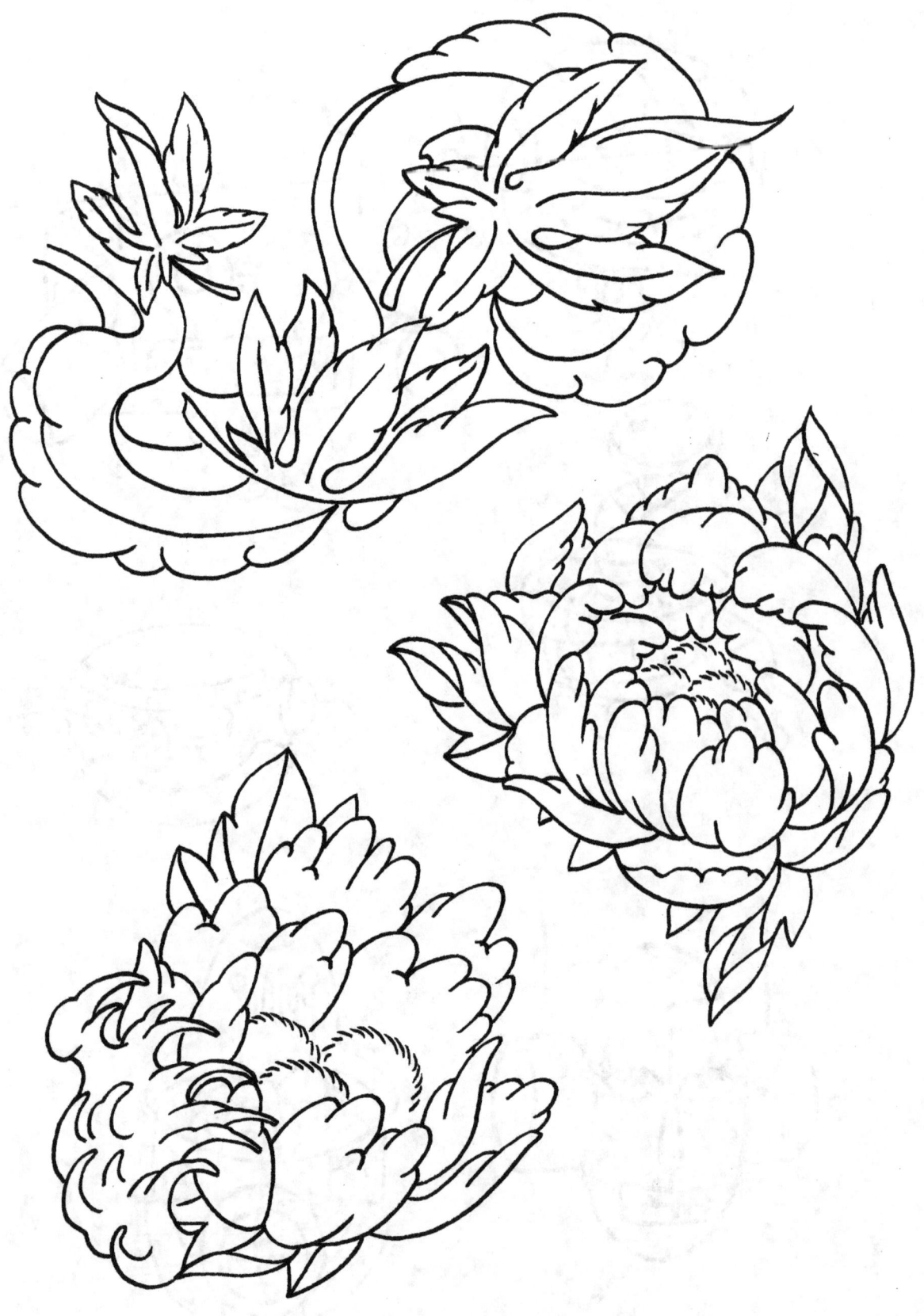

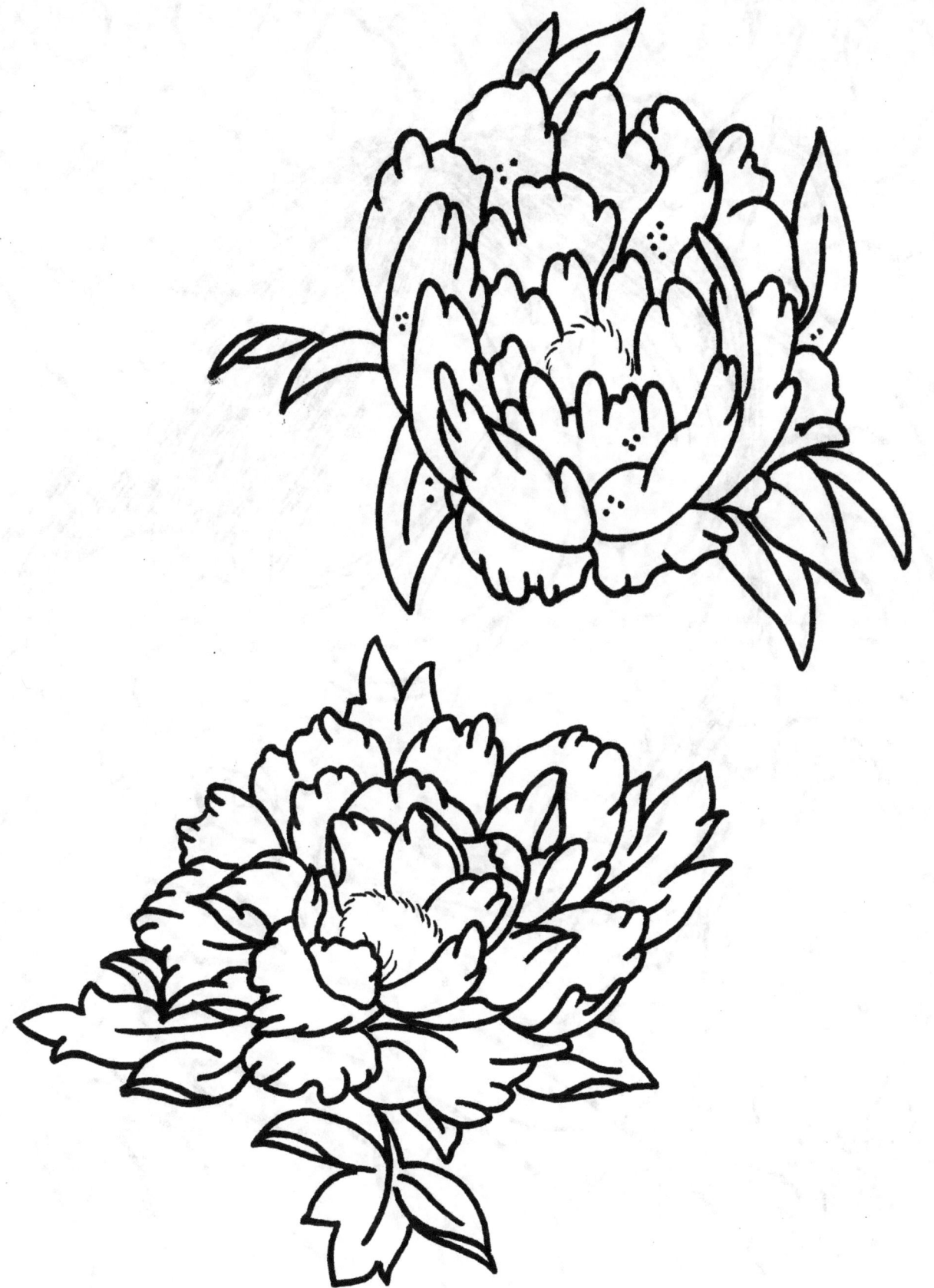

Paul Trimble Has A Posse

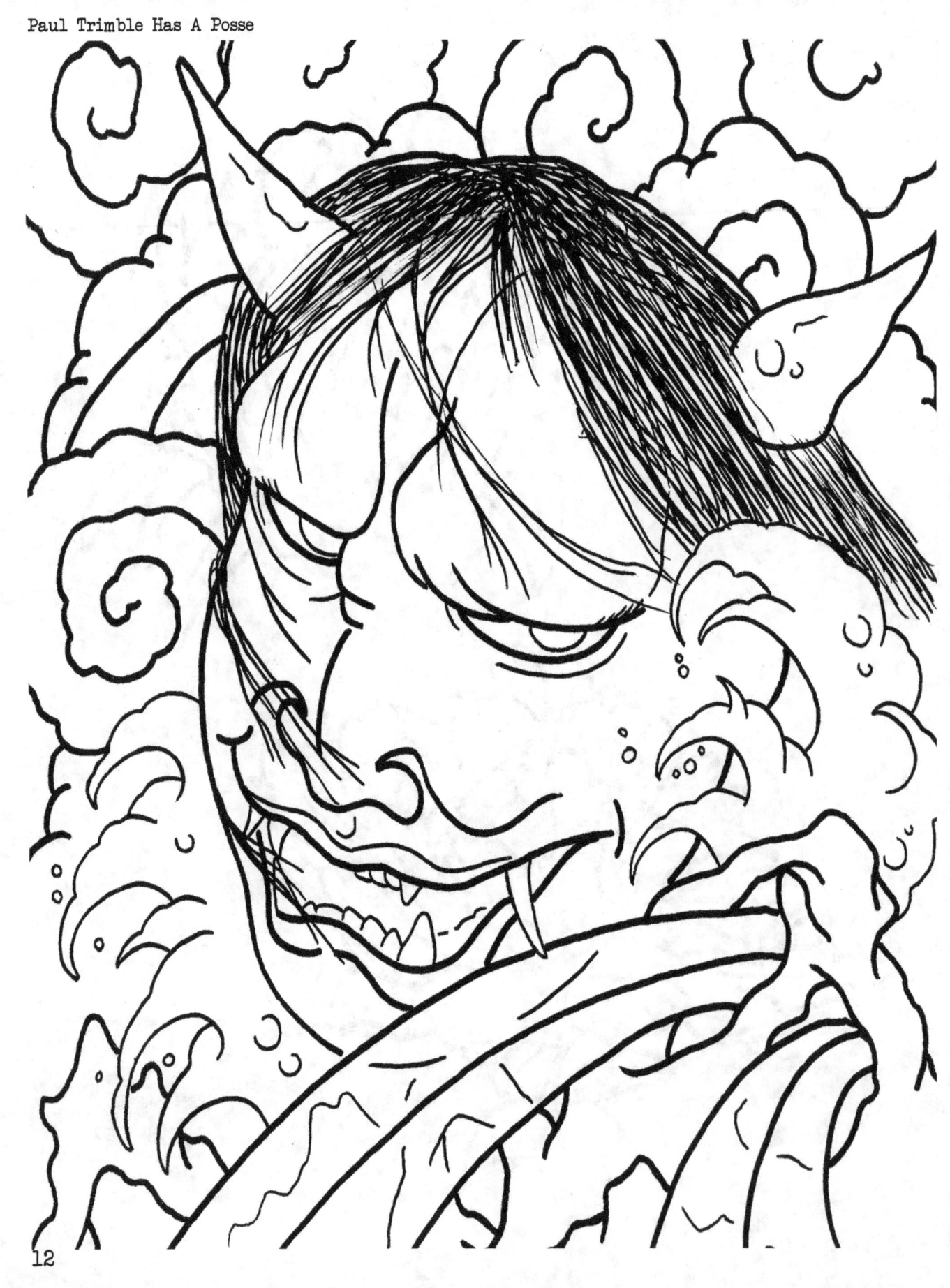

Devin Sheehy

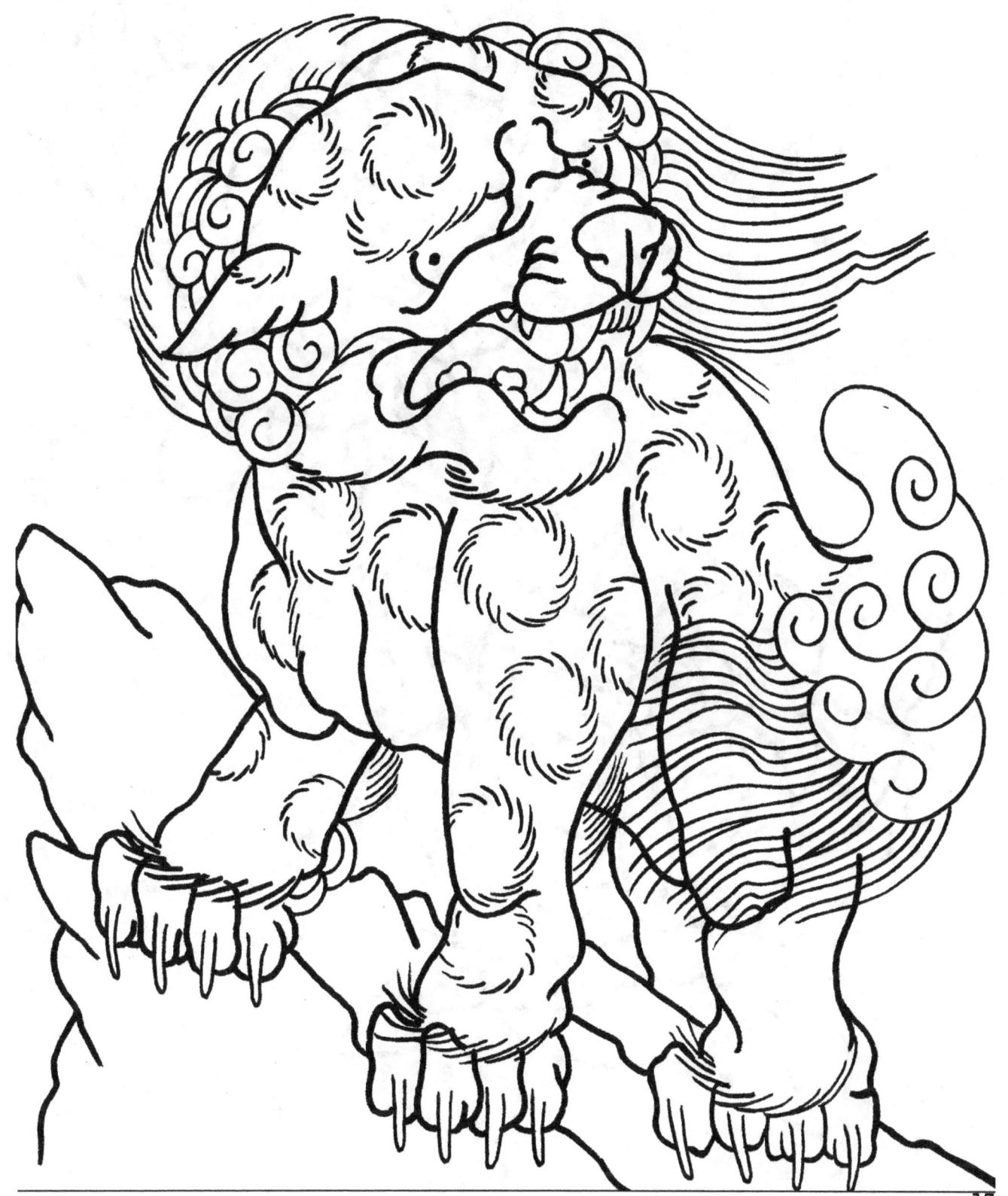

Paul Trimble Has A Posse

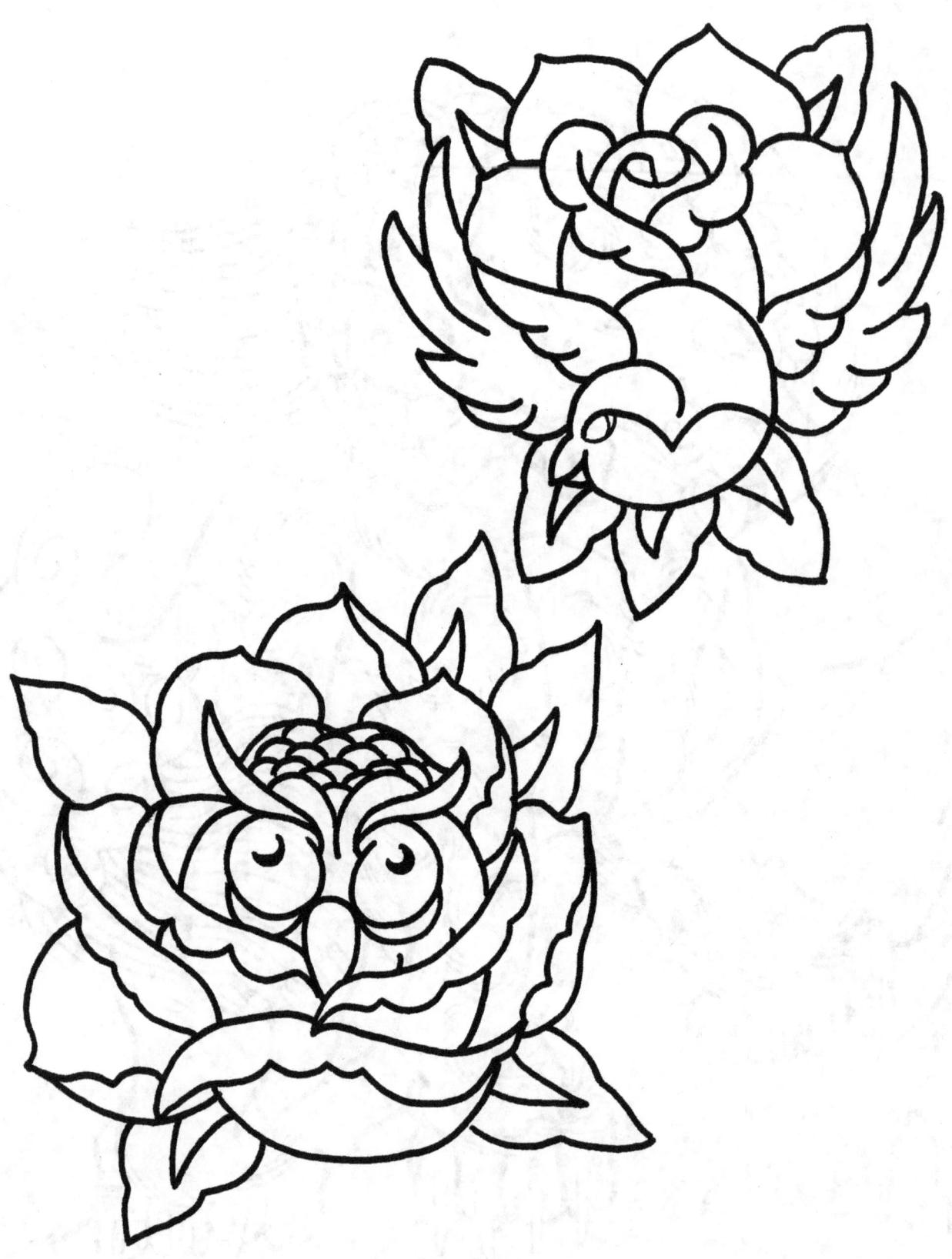

Devin Sheehy

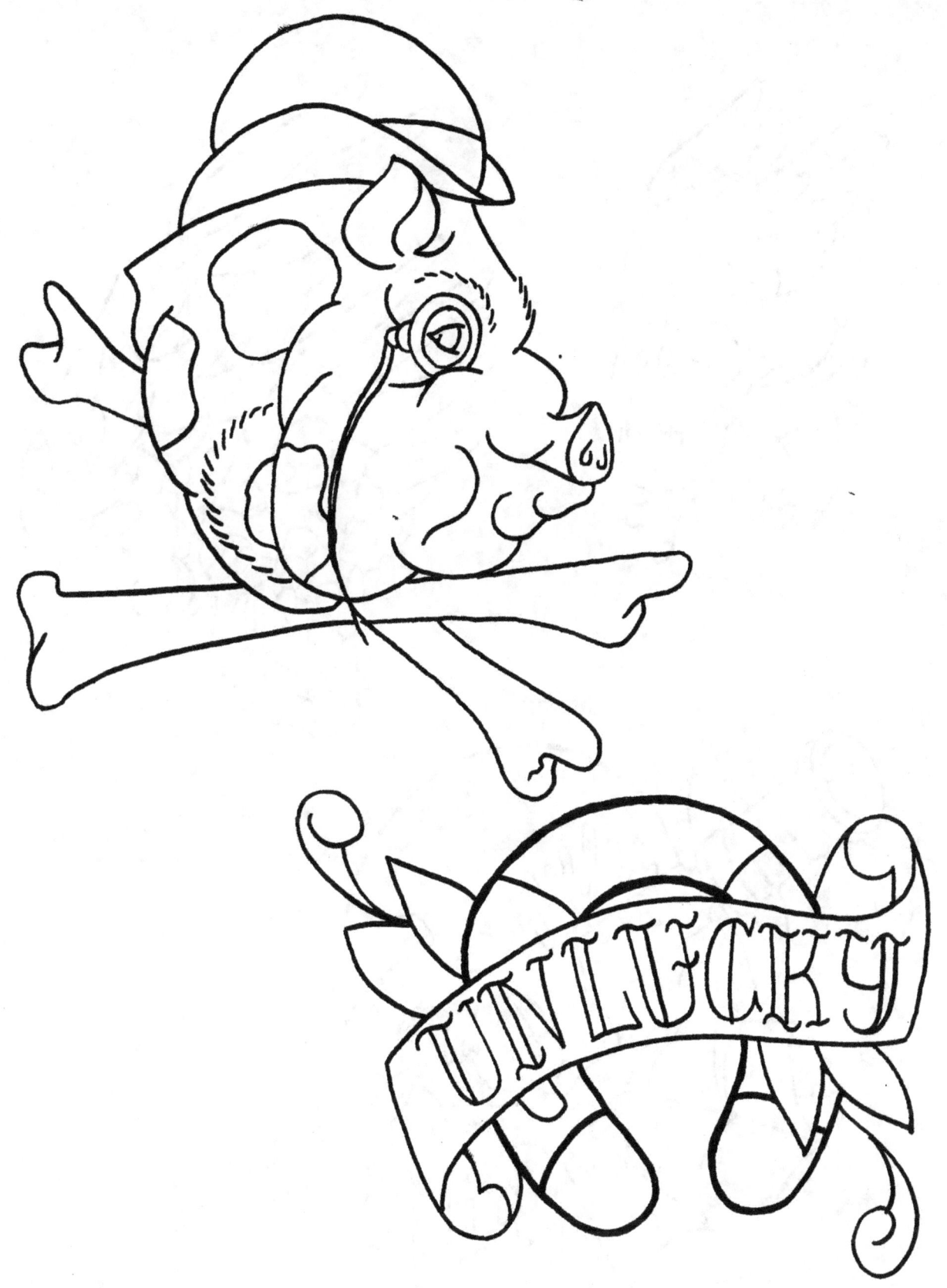

Paul Trimble Has A Posse

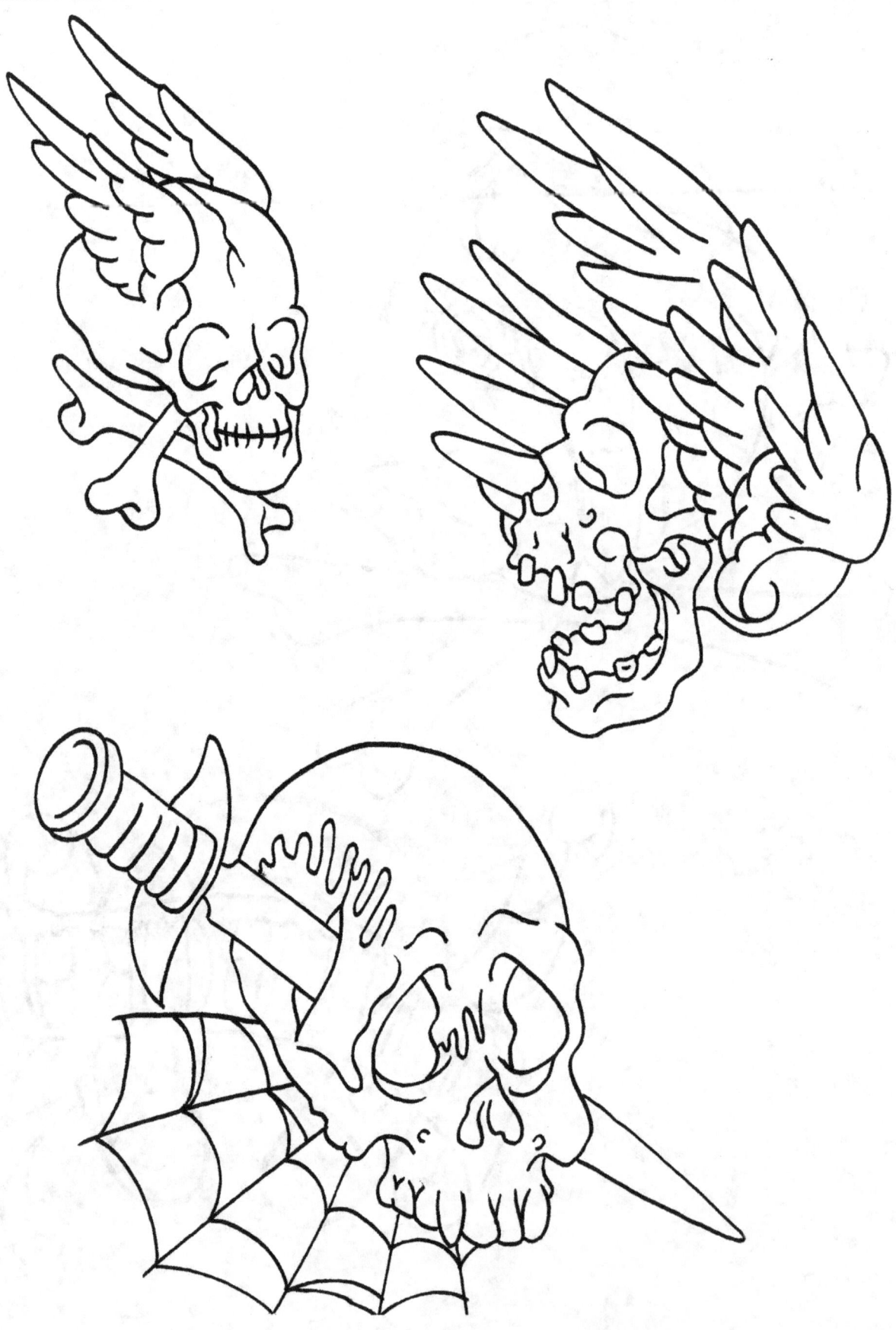

Devin Sheehy

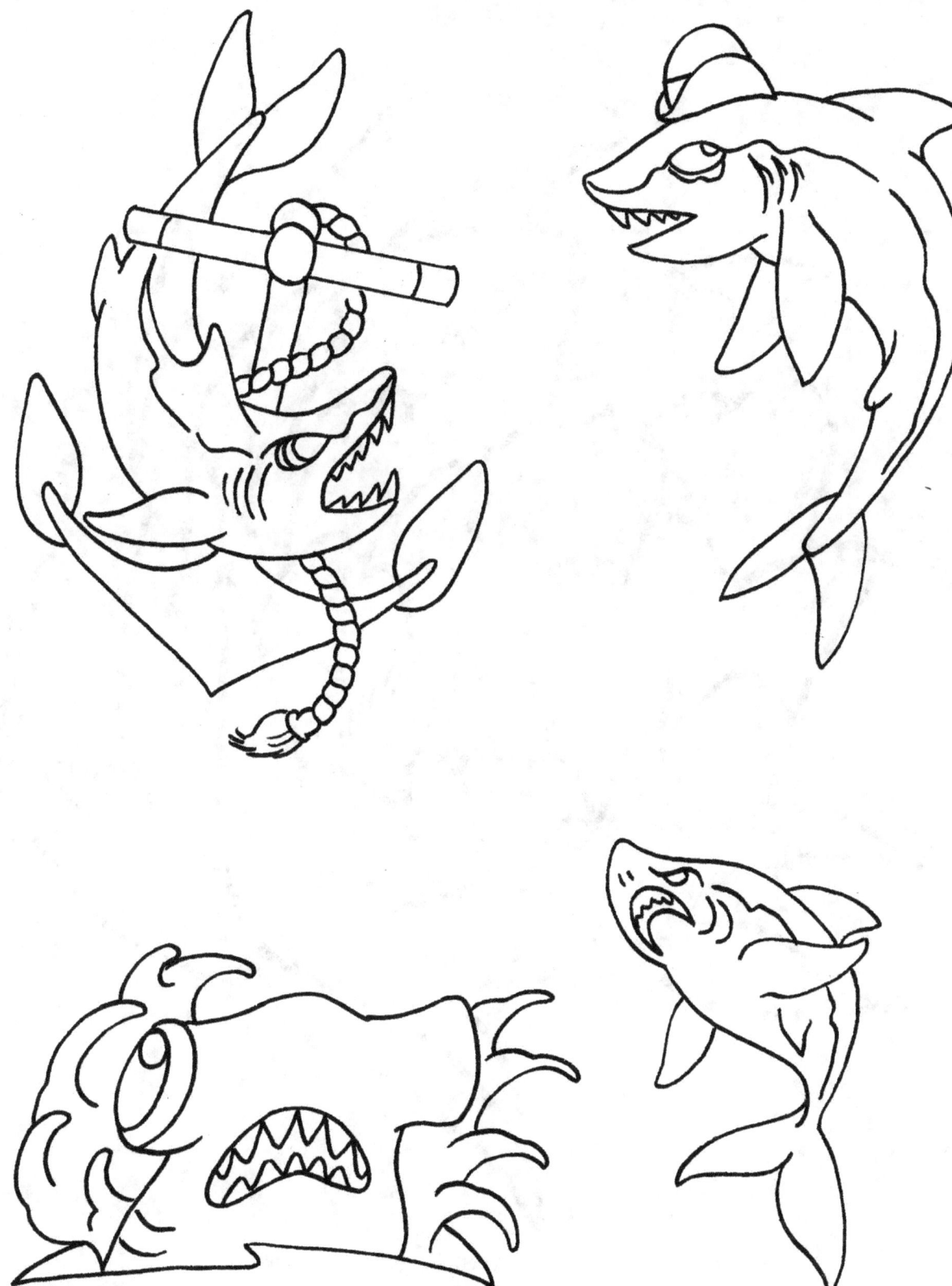

Paul Trimble Has A Posse

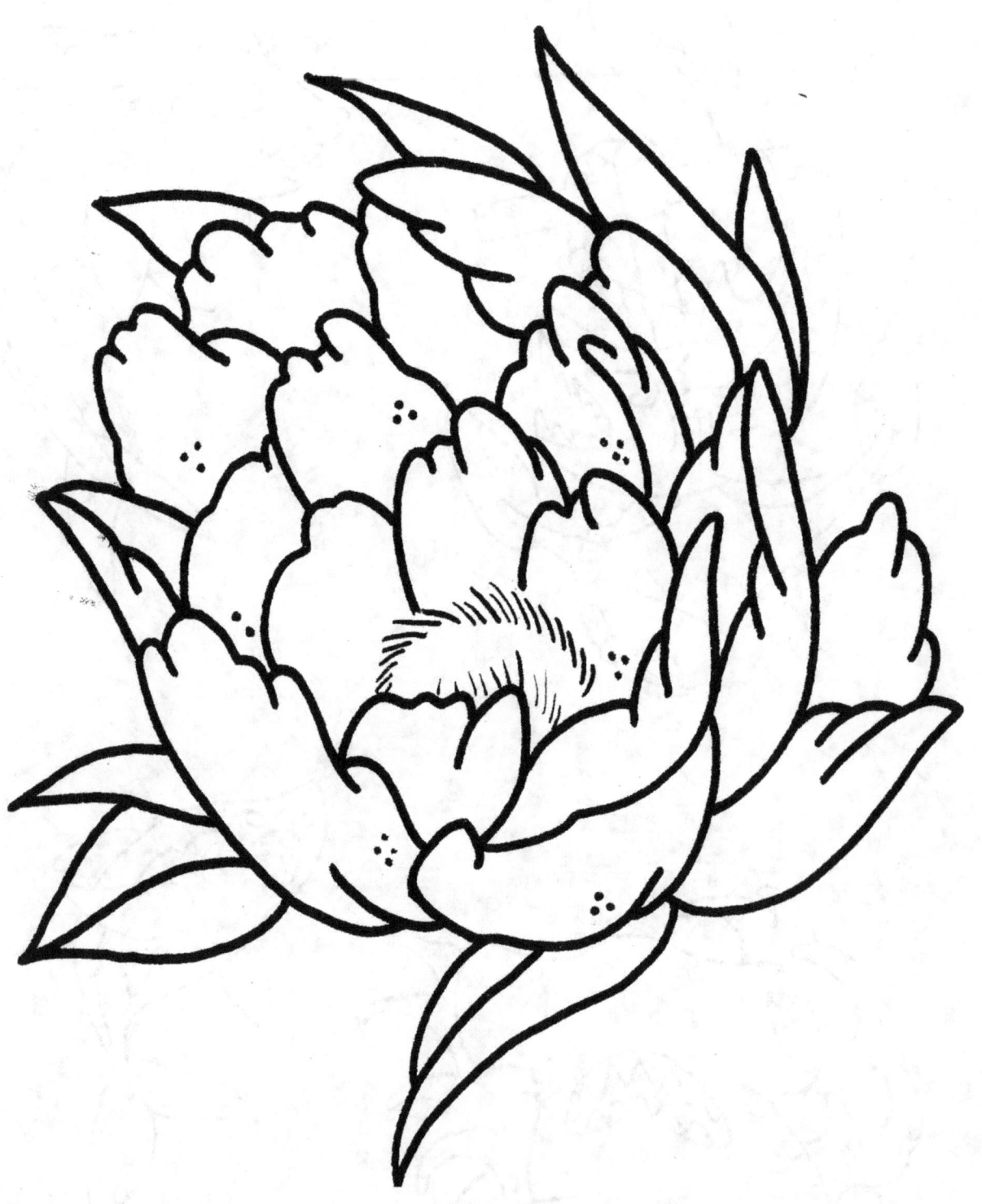

Devin Sheehy

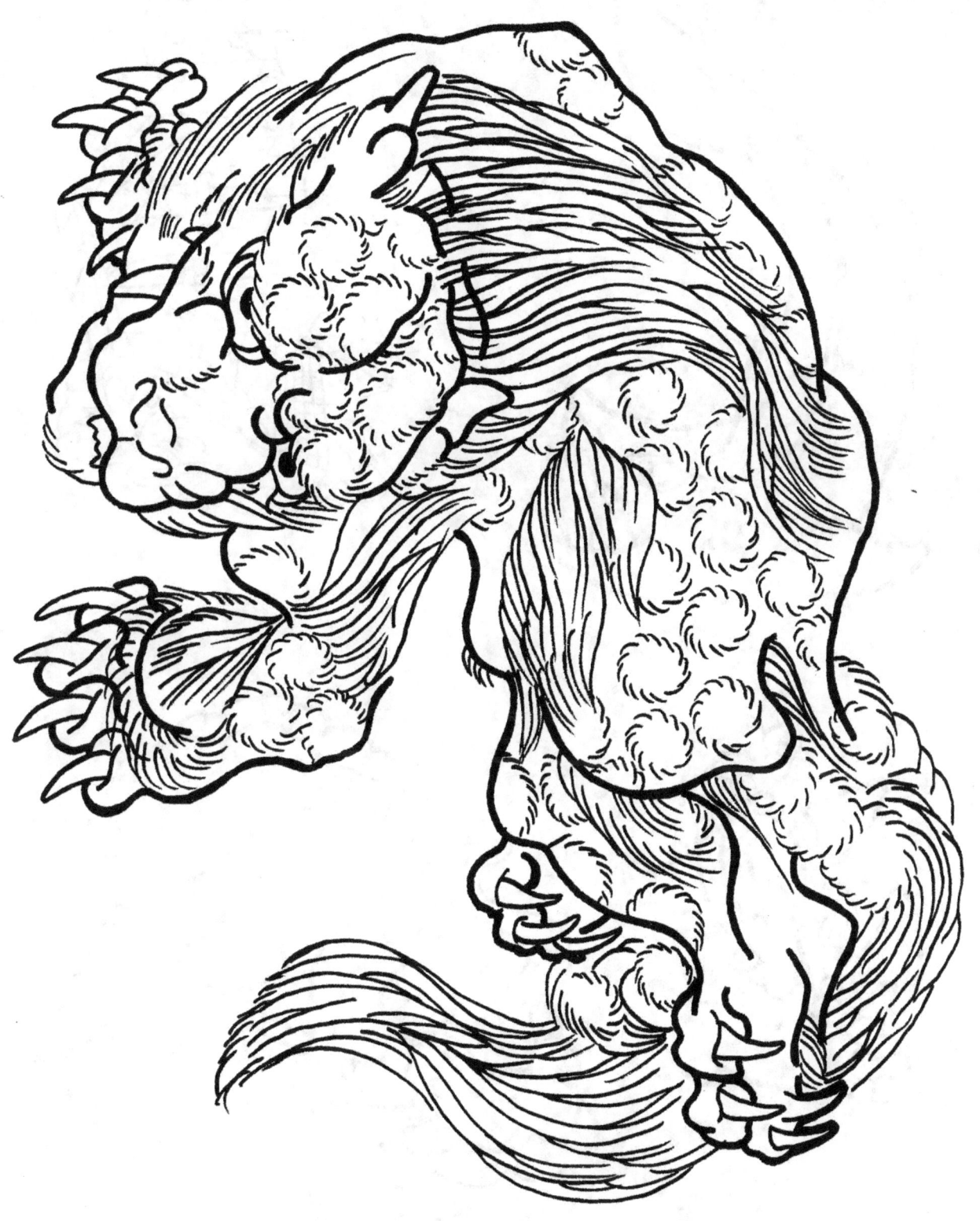

Paul Trimble Has A Posse

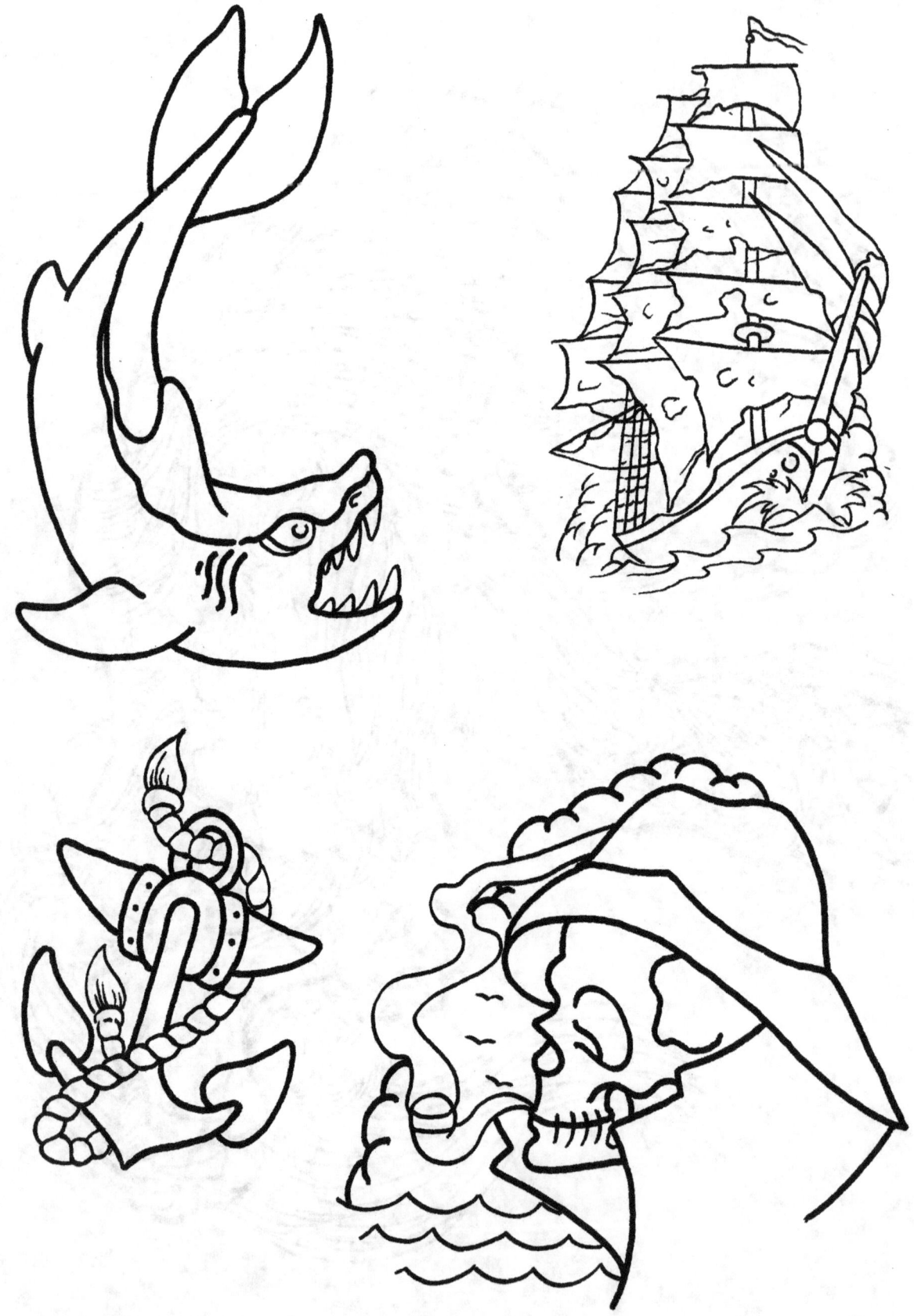

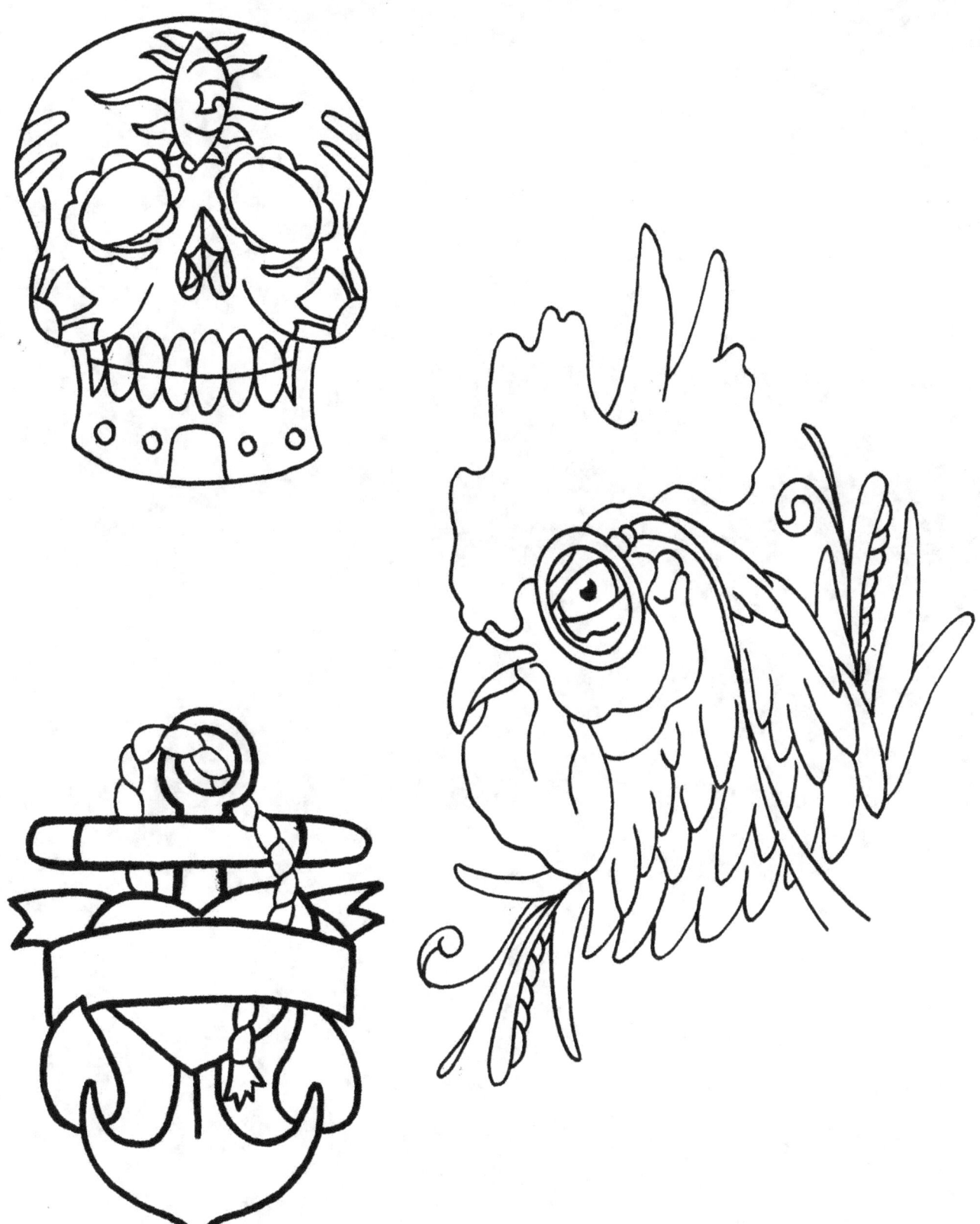

www.ingramcontent.com/pod-product-compliance
Lightning Source LLC
Chambersburg PA
CBHW081136180526
45170CB00008B/3123